Roanoke County Public Library
South County Library
6303 Merriman Road
Roanoke, VA 24018

NO LONGER PROPERTY OF ROANOKE COUNTY PUBLIC LIBRARY

Water Soluble Pencils

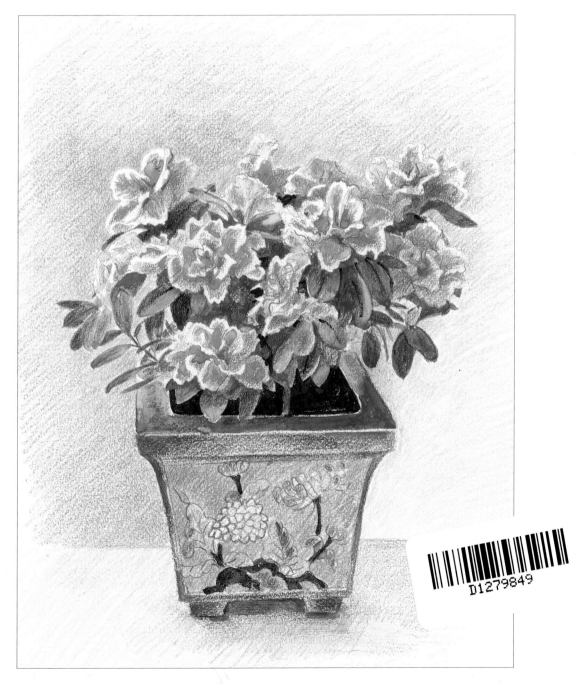

D1279849

NO LONGER PROPERTY OF ROANOKE COUNTY PUBLIC LIBRARY

Especially for Eric, Charity and Sam.

0 1197 0647716 1

Water Soluble Pencils

CAROLE MASSEY

SEARCH PRESS

First published in Great Britain 2001

Search Press Limited
Wellwood, North Farm Road, Tunbridge Wells, Kent TN2 3DR

Reprinted 2002, 2004, 2005 (twice), 2007, 2008, 2009, 2010

Text copyright © Search Press Ltd. 2001

Photographs by Search Press Studios
Photographs and design copyright © Search Press Ltd. 2001

All rights reserved. No part of this book, text, photographs or illustrations may be reproduced or transmitted in any form or by any means by print, photoprint, microfilm, microfiche, photocopier, internet or in any way known or as yet unknown, or stored in a retrieval system, without written permission obtained beforehand from Search Press.

ISBN: 978 0 85532 963 1

The publishers and author can accept no responsibility for any consequences arising from the information, advice or instructions given in this publication.

Suppliers
If you have difficulty in obtaining any of the materials and equipment mentioned in this book, then please visit the Search Press website at www.searchpress.com for details of suppliers. Alternatively, you can write to the publishers at the address above, for a current list of stockists, including firms which operate a mail-order service.

Publisher's note

All the step-by-step photographs in this book feature the author, Carole Massey, demonstrating how to draw and paint with water soluble pencils. No models have been used.

There is a reference to sable hair and other animal hair brushes in this book. It is the publishers' custom to recommend synthetic materials as substitutes for animal products whenever possible. There are a large number of brushes made from animal hair available, and these are just as satisfactory as those made from animal fibres.

Printed in Malaysia

My grateful thanks to Roz, Ally, and the Search Press team for their encouragement and enthusiasm for this, my first book.

Cover: **Autumn**

This contre-jour (against the light) view of sunlight filtering through the golden beech leaves was stunning, and I particularly liked the pattern of shadows from the fence posts falling down the grassy bank.

Page 1: **Azaleas**

I drew the whole composition with dry pencils, putting in all the colours with a selection of cool pinks for the flowers, and dark, bluish greens for most of the foliage. Then I systematically blended each area with water, adding more colour to strengthen areas where required. I treated the pot in the same way, leaving white paper for highlights.

Page 2/3: **Norfolk Landscape**

I love this glimpse of the sea and sailing boats seen through the tangled summer hedgerows. I have used various wet and dry techniques as well as masking fluid, to help to create the contrast between the busy foreground detail and the distant coastline.

Page 5: **Blue Hyacinths**

The contrast between the blue flowers and the bright yellow trug inspired this still life. I drew the picture using dry pencils, blending each area with water and adding more colour to strengthen the colour in some places. I added a shadow round the base of the trug to stop it 'floating'.

Contents

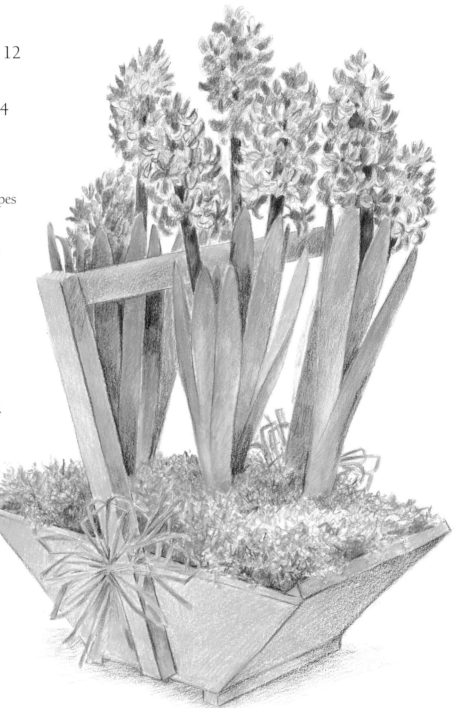

Introduction

Many people believe they cannot draw, but if you can sign your own name, you have all the basic drawing skills you need to create a picture. It is simply a question of training your eye and mind to draw what you see, rather than what you think you see.

A child's first drawing implement is usually a pencil, so when you begin to use water soluble pencils, they already feel familiar. Add water, and you can turn your drawing into a painting, almost as if by magic. This book will show you how to work with water soluble pencils, taking you in easy steps through the stages you need to begin creating your own pictures.

The techniques covered include drawing, understanding colour and the use of tone, as well as various methods of using water soluble graphite pencils and water soluble coloured pencils. Examples and step-by-step demonstrations help you to explore the full potential of this exciting medium.

Water soluble pencils – coloured and graphite – are ideal for both the beginner and the more experienced artist. They are user-friendly, clean, relatively inexpensive, easy to use and versatile. The transition from drawing to creating tonal washes or a 'watercolour' painting is simple, requiring nothing more complex than a brush and some water. It is true that the pencils lack the vibrancy of watercolour, but some very pleasing effects can be achieved. Some interesting textural effects can also be produced by experimenting with different types of paper.

Water soluble pencils are excellent for use out-of-doors. Lightweight and portable, they are the perfect medium for the traveller and can be used with inks, pastels, charcoal and watercolours to produce some exciting effects. As with any new skill, practice really does make perfect - so keep practising!

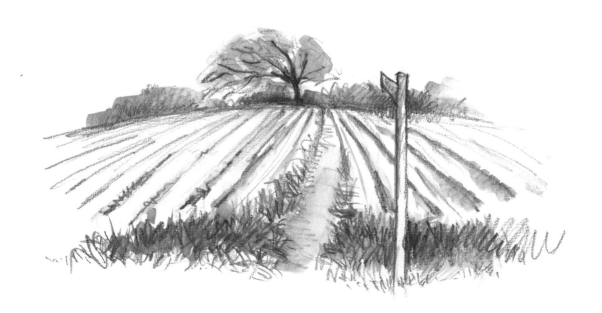

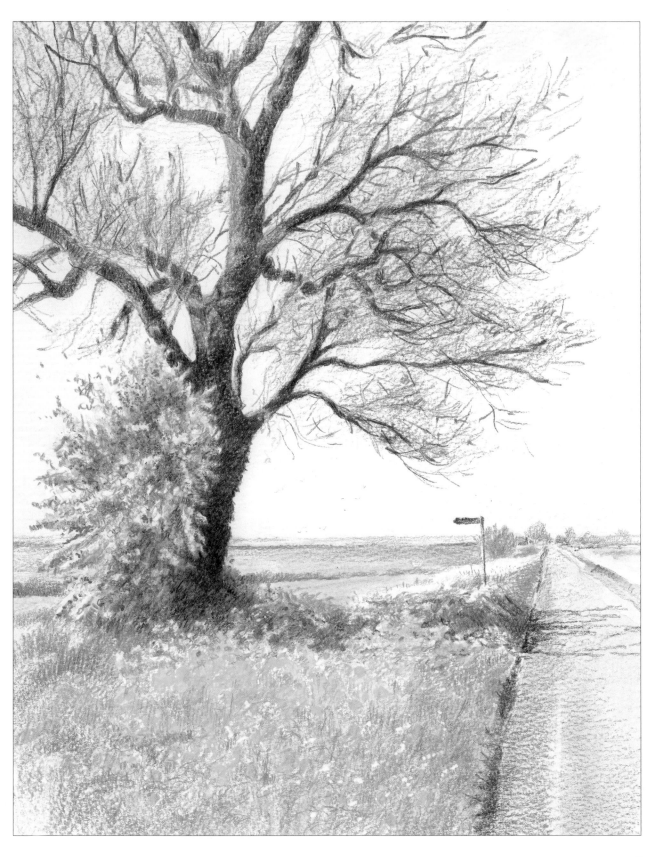

Materials

Water soluble pencils look like standard coloured pencils, but the binder used to form the pigment into the 'lead' or 'strip' is soluble in water. They are sold singly or in boxed sets; it may be best to start with a small set and add other colours as you need them. They are not graded like graphite pencils, but different makes will vary in degree of hardness so it is best to try them out before painting. Texture, too, will vary between makes. You will find the softer ones easier to dissolve and move around on the paper.

The soluble binder used in water soluble pencils means that they are waxier than ordinary coloured pencils – midway between a pencil and a crayon – and are also effective used dry. They can be erased when dry, before water is added. Once a wash has dried you can add further layers of colours and re-wet to build up darker areas. For a more intense colour, you can also draw straight into wet or damp areas (wet-in-wet).

Water soluble graphite pencils are used in a similar way to standard graphite ('lead') pencils, but produce a variety of grey washes when wet. Distinguishable from other pencils by a small brush or raindrop symbol on the shaft, they are available in three different grades to produce a range of grey washes.

Note *You do not need a great deal of water when working with water soluble pencils – you will find that the water does not become dirty.*

1&2 Water soluble pencils

3 Crayons

4&5 Water soluble graphite

6 B and 2B pencils (non-soluble)

7 Broader (stubby) pencils

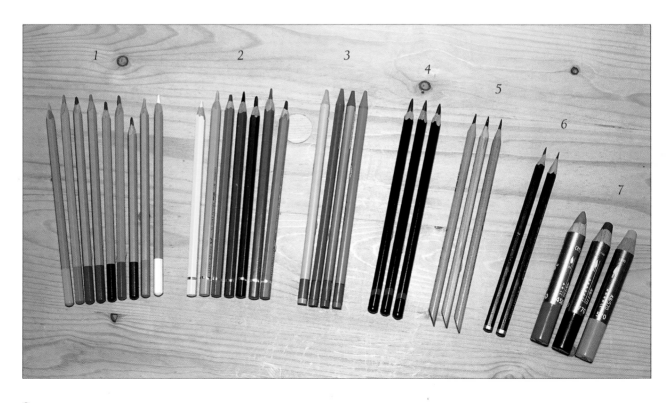

Paper

White or tinted watercolour paper is ideal for use with water soluble pencils. You can choose from various surface textures, depending on the effect you want to achieve. These include smooth (also known as hot-pressed or HP); semi-rough (also known as cold-pressed or Not) and rough. Bockingford 300gsm (140lb) Not will stand up to a fair amount of re-wetting and reworking, so it is a good paper for beginners.

If you want to use a lighter paper like cartridge, and plan to use water on a large area of your picture, it is best to stretch it to prevent cockling.

Most of the paintings featured in this book were done on paper sized approximately 38 x 28cm (15in x 11in) stretched on to a drawing board.

Brushes

A good brush will always keep its shape and form a good point when wetted. Good quality synthetic or synthetic/sable blend brushes have the right 'spring' and resilience needed to push the pigment across the surface of the paper. A No. 8 and a No. 5 are suitable for most work. For a big area of wash, you might find a No. 12 or No. 14 brush useful.

A range of papers including Bockingford; tinted Bockingford (Not); Arches (semi rough); Waterford (HP); cartridge and pastel papers.

Stretching paper

Light- and medium-weight papers may need to be stretched to prevent the surface cockling when you add water. To do this, you will need a drawing board and four lengths of brown gumstrip paper 36mm (1½in) wide, cut slightly longer than the sides of your paper. Wipe over the board with a sponge and clean water, then lay your paper on the board and wet its surface, pushing out any creases.

Moisten the gumstrip with your sponge and stick it to the paper, overlapping the edge by about 10mm (³/₈in). Repeat on the remaining sides, ensuring that the gumstrip is stuck well down. Leave the paper to dry naturally. Paper stretched in this way will always dry completely flat. When your painting is completely dry, remove it by cutting between the paper and the gumstrip with a sharp knife.

Top: No.5 round
Middle: No. 8 round
Bottom: No.10 round.

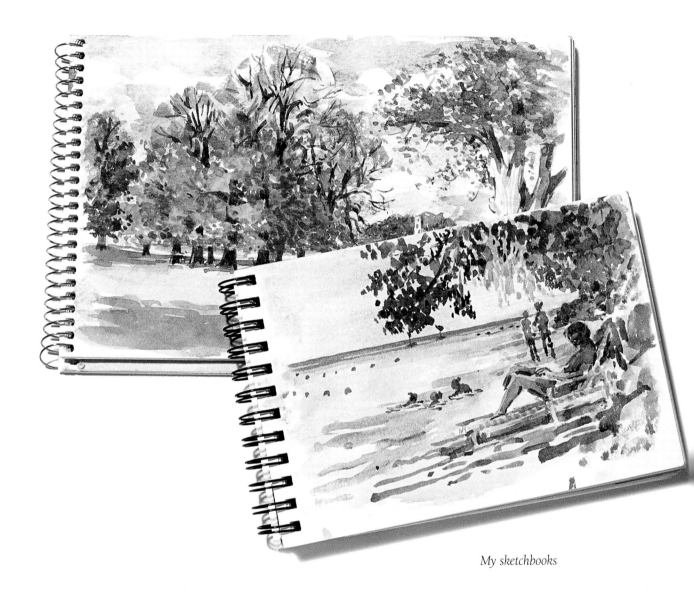

My sketchbooks

Sketchbook

Get into the habit of keeping a sketchbook. Draw as often as you can – figures, animals, trees, buildings, clouds – anything and everything! Sketching is the best way to improve your powers of observation and drawing ability, and it will also give you a ready supply of material to include in your paintings. If you do not have much time, you can jot down notes to refer to later. Water soluble pencils are an ideal sketching medium because you have the facility of line, colour and wash in one.

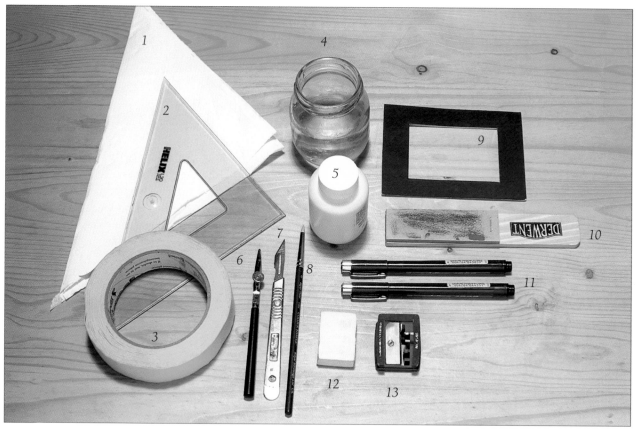

1. **Absorbent tissue** *for mopping up spills and blotting damp areas.*

2. **Small set square** *for measuring right angles.*

3. **Masking tape** *for fixing paper to your drawing board.*

4. **Pot** *to hold water.*

5. **Masking fluid** *for reserving fine details, or for use on areas which might otherwise be lost when you add a wash. When the painting is completely dry, remove it by rubbing lightly with your finger, or use an eraser.*

6. **Ruling pen** *for applying masking fluid.*

7. **Scalpel** *or* **craft knife** *to keep your pencils very sharp.*

8. **Silicone shaper** *for use with masking fluid.*

9. **Viewfinder** *for framing a view (see page 21).*

10. **Sandpaper block** *for maintaining a sharp point on the pencils.*

11. **Drawing pens** *for defining the drawn image on tracing paper.*

12. **Kneadable (putty) eraser** *for drawing in highlights or for using in small areas of your picture. It can be shaped for easy use and leaves no residue.*

13. **Jumbo pencil sharpener** *to use with stubby pencils.*

Not shown:

Drawing board *I use a piece of 6mm (¼in) medium-density fibreboard about 470 x 360mm (18½ x 14¼in).*

Gumstrip paper *use this to fix your work to your drawing board when stretching paper.*

Sponge *to moisten the gumstrip paper.*

> **Note** *there is no palette listed as you do not need one with water soluble pencils.*

Understanding colour

Water soluble pencils come in a rainbow of colours. It is a good idea to improve your understanding of colour before you start painting, by making a colour wheel. Familiarise yourself with your own range of colours, and make some charts. Though you may think you have a wide range of colours in your set, there will often be those subtle hues you cannot match. Do not despair! In time you will learn that by blending and building up layers and washes, you can create almost any colour.

The colour wheel

Primary colours (red, yellow and blue) are those which cannot be created by mixing other colours.

Secondary colours (purple, orange and green) are made by mixing two primary colours.

Complementary colours are opposing, yet harmonious groups of colours which can be used to enhance one another or mixed to give a good range of greys and browns. They are found opposite each other on the colour wheel: blue – orange; red – green; yellow – purple.

Note The fact that cool colours appear to recede and warm colours seem to come forward can be used to create a sense of depth in your paintings if you choose carefully.

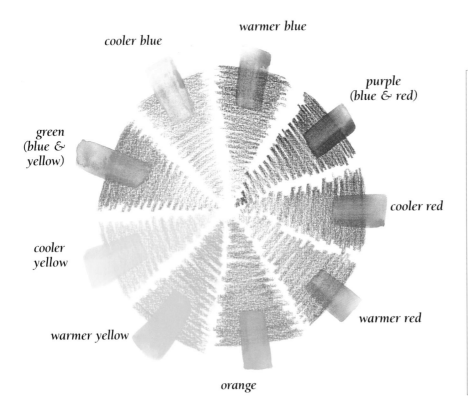

warmer blue

cooler blue

*purple
(blue & red)*

*green
(blue &
yellow)*

cooler red

*cooler
yellow*

warmer red

warmer yellow

orange

Warm and cool colours

As you can see from the colour wheel, each colour has a cool and a warm version.

Cool colours (examples)
Yellows: lemon; zinc yellow

Blues: light blue; pthalo blue

Reds: crimson; magenta; carmine red; dark red

Warm colours (examples)
Yellows: cadmium; straw

Blue: ultramarine

Reds: scarlet lake; cadmium red; vermilion

Colours which appear similar when dry can often look quite different when water is added. In the example above, burnt carmine and burnt umber are shown both dry and wet.

Greens can sometimes look quite garish, but adding a small amount of a complementary colour from the red/brown/purple range will tone down the colour effectively.

For lively shadows, use the blue/purple range of colours, not browns and black, which can look muddy or dull.

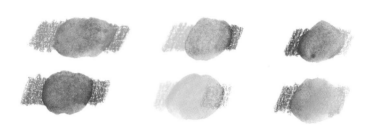

Blend two similar colours for a more interesting, richer result, e.g. for blue sky use ultramarine and sky blue; for vibrant red use vermilion and orange; for sunlit leaves use grass green and cadmium yellow. A red next to a green will exaggerate its greenness. A touch of red mixed into a bright green, however, will calm down, or neutralise it.

Mixing complementary colours (a primary colour and a secondary colour e.g. red and green) together will produce a variety of rich greys and browns.

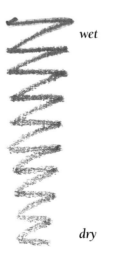

wet

dry

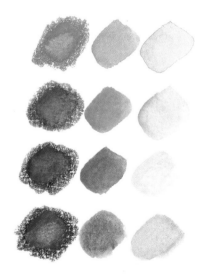

The colours (ultramarine and cadmium red) have been scribbled on to dry, then wet paper.

This example shows the effect of scribbling with a wetted pencil tip, which produces a paler effect as it dries out.

You can make a small palette by scribbling a colour on a spare piece of paper, and lifting the colours off with a damp brush to use on your painting.

13

Playing with pencils

I have drawn a variety of shells to show the different ways in which water soluble pencils can be used.

Whelk shells

The shell on the left was drawn with water soluble medium wash and dark wash, graphite pencils, without adding water.

I sketched the shell on the right using a medium wash pencil. Switching to a dark wash pencil, I added shading. With a wet brush I washed in the dark interior and the shaded parts, then with the pigment left on the brush, I painted some stripes on the shell. Wetting the graphite has created a far more interesting study and a greater range of tones.

Three shells

I used orange, brown, yellow, and blue water soluble pencils to draw the shells and their markings, adding a complementary bluish-purple shadow. I blended the colour to make the patterns using a damp brush. The blue-purple shadow area in the background, which contrasts with the colour and shapes of the shells, was painted with a wet brush.

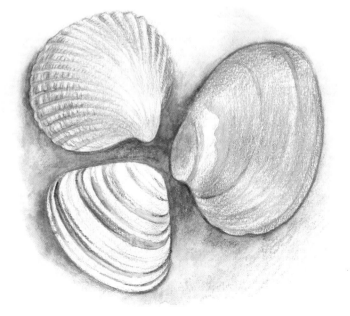

Tropical shell

This shell had irregular markings in strong black over soft pinks and yellows, so I drew the outline with a grey pencil, then put in the lighter tints. I wetted the whole area with clean water, and used a black pencil to draw the darker, squiggly markings. I let the painting dry, then coloured in the inner scoop and the shadow using ochre, greys and browns, and wetted these to blend the colours. In some areas, I added more black or dark brown, dipping the tip of the pencils in the water where I wanted the colour to be even more intense.

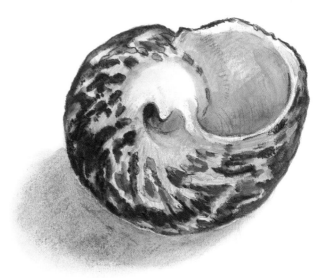

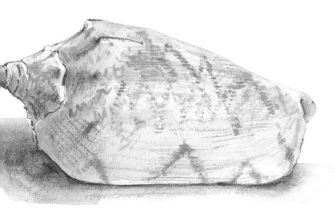

Long shell

This shell was a delicate, creamy pink with fine zigzag markings. I sketched it with a pale purple pencil, adding pinks and yellows and leaving a white space in the central section, which I rubbed with candle wax. I then wetted the area and blended the colours, leaving white highlights on the 'shoulder'. I drew in the markings with orange and burnt sienna, then used a wetted purple pencil to draw in more defining lines on the left. The shadow was sketched in lightly with purple and chocolate brown, then blended with water. I scratched through the wax with a sharp blade to increase the central highlight.

Oyster shell

This shell had a highly-textured surface with lots of frilly layers and several barnacles. I used graphite and water soluble pencils, combining wet and dry methods and re-drawing with a wetted pencil where I wanted more intense colours, but leaving dry areas to create a rough texture. The complex detail was simplified to retain the overall form of the shell. I drew stronger lines at the front, with a wetted brown pencil, and left more highlights to create both shape and recession. I made the shadow blue, to complement the yellow-brown colour of the shell.

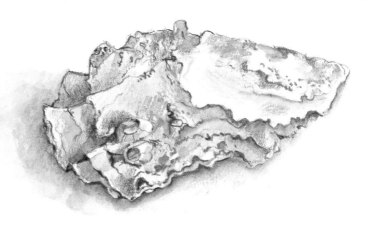

15

Beginning to draw

Drawing is fundamental to successful painting, and is about learning to draw what you see, and not what you think you can see. Measuring, looking at the positive and negative shapes, and understanding how to deal with tonal values will all help you to interpret accurately what is in front of you.

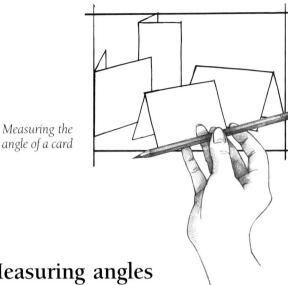

Measuring the angle of a card

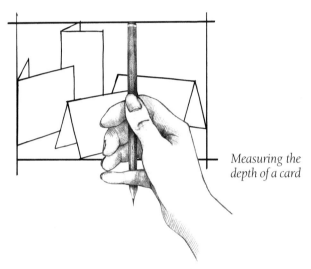

Measuring the depth of a card

Measuring proportions

Arrange four cards in a group. Plan the area and shape of your drawing by measuring the comparative height and depth of the group.

Hold the pencil vertically at arm's length with your arm straight. Close one eye and line up the top of the pencil with the highest point of the tallest card, then slide your thumb down to line up with the lowest point of the nearest card. Keeping your thumb on this mark, turn the pencil to a horizontal position and compare the width. Sketch in a box which represents these proportions.

Now plan the positions of the cards, starting in the centre. Check the relative height and width of each one, making sure you are happy before moving to the next. Keep looking at the whole composition, gradually building up an accurate picture. When all four cards have been drawn, adjust if necessary.

Measuring angles

Lines which are neither vertical nor horizontal can be difficult to achieve. One way to do this is to line up your pencil with the element of the composition you wish to draw. Holding the pencil at the same angle, lower it to check the corresponding line on the drawing. Adjust if necessary.

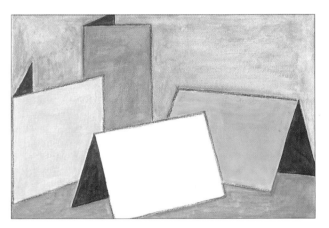

Positive and negative shapes

The positive shape of objects is often so familiar that preconceived ideas about how they look can hinder your approach to drawing them. Concentrating on the *negative* shapes between and around objects will give you an impartial, more accurate approach.

In the illustration above I have painted the negative shapes in blue, orange, purple and green. Another good exercise is to draw a chair looking only at the negative shapes.

Understanding tone

Tone is how dark or light a subject appears compared to its surroundings. It is independent of, and often more important than, colour in a painting.

One of the reasons a painting may look flat or dull is lack of tonal contrast, so it is important that you understand how to use tone. A dark object may appear quite light in parts, and a pale object may have some very dark areas. Translating these tones will give your painting depth and vitality. Screwing up your eyes will help you to judge the darkest and lightest areas more easily.

Drawing position

Sit facing your subject and try to work with your sketchbook or board as upright as possible. Draw from the shoulder or elbow, not just from the wrist. Stand up and walk away from your drawing every twenty minutes or so. You will be surprised how easily you will be able to spot any mistakes.

Still Life with Lamp

It is the tone, rather than the colours, which make this composition work. The table is dark brown, but seems as light as the lamp where it is reflecting the light. Successive layers of colours were blended before adding water. The background and lampshade were left dry.

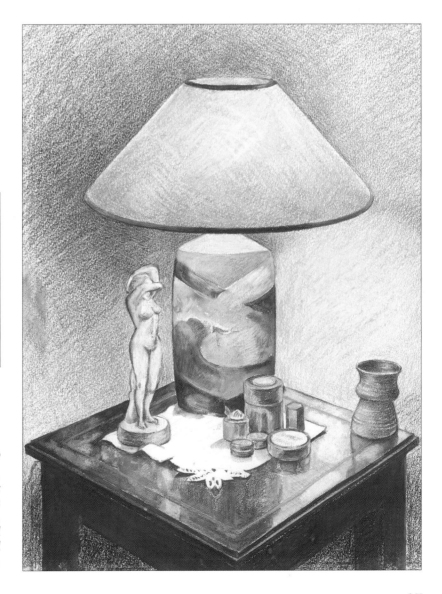

Using photographs

Photographs, particularly those you have taken yourself, can be a wonderful source of inspiration. It is said that the camera never lies, but it can alter colours and tones and distort tall buildings. Skies may lack colour, and shadows appear far darker and with little definition.

Use photographs selectively as a reference from which your painting can evolve. I used the photograph (right) to create the painting below, lightening the shadows and adding texture.

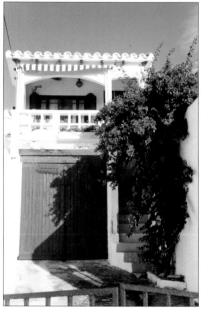

Source photograph

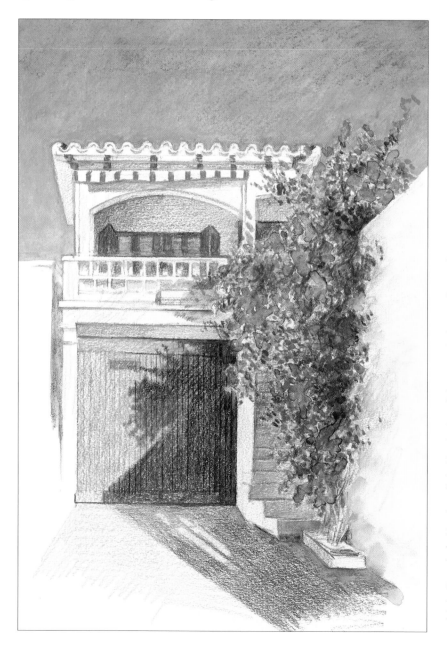

Spanish villa

I was attracted to this view by the strong sunlight catching the cerise pink flowers, contrasting with the cast shadows which form interesting diagonals against the vertical lines of the villa. Some of the areas in the photograph look very dark, however, so I have lightened the shadow on the door, the dark green foliage, the stairs and the foreground shadow. The sky and the flowers are the only areas to which I have added water, making the sky an intense, flat blue and the flowers a vivid pink. Texture and interest have been created on the green door by using dry pencils, drawing the fine vertical lines of the woodwork with a ruler and well-sharpened black pencil. Shadows which look dark brown, grey or black in the photograph are brought to life by using blues and purples.

Dovecote

This is a good example of how a camera can be invaluable for 'arresting' motion. I used several shots of the doves to plan the composition, positioning the flying birds diagonally across the painting and reversing one of the doves so it flies into the picture. The dovecote is a fairly complicated structure, so I enlarged it with the help of photocopies and a grid (see page 33).

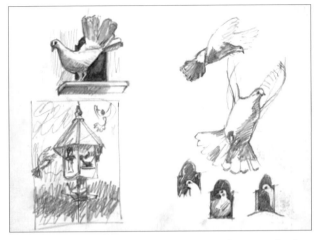

Preliminary sketches

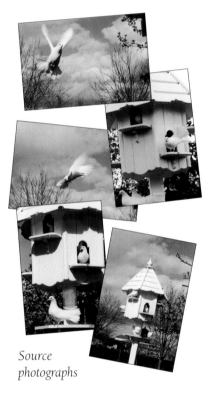

Source photographs

The finished painting

I made the clouds darker to contrast with the whiteness of the dovecote in the spring sunshine. The top half of the composition is quite busy, so I replaced the background in the photographs with green fields to provide a simple, distant backdrop. The hedge was painted in a far lighter colour, with yellow and browns added to break up the green.

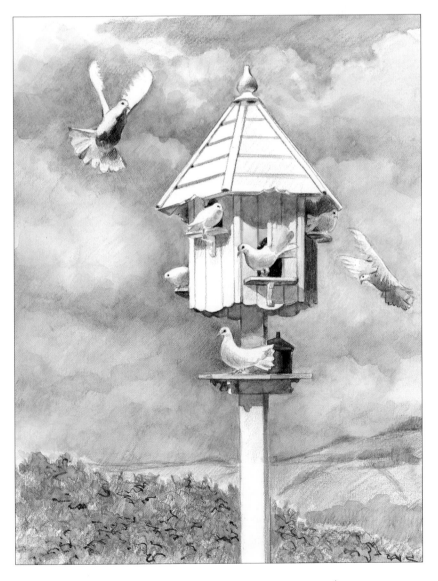

Composition

Composition is the plan or layout of your painting, and a good composition is one which you can look at time and time again and always find interesting. There are certain rules which can be followed to help create a more stimulating painting:

Rule of thirds

In general, avoid dividing the picture in half either horizontally or vertically. In Figure 1, the sailing boat falls awkwardly in the centre, and the horizon divides the picture into two. In Figure 2 the position of the horizon, boats and birds all follow the rule of thirds. Note that positioning an object slightly off-centre makes the spaces either side more interesting (see the picture of the dovecote on page 19).

Focal point

If we divide the picture into thirds the lines cross at four focal points – ideal points to position anything you want to emphasise.

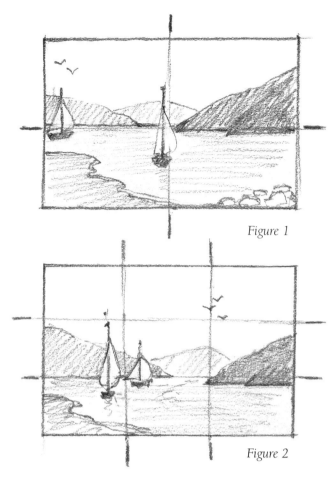

Figure 1

Figure 2

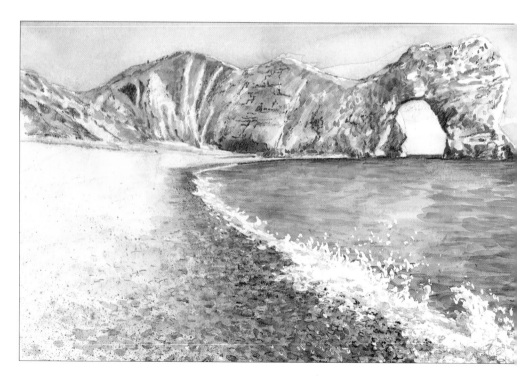

Dorset Coastline

In this painting of the sea and rocks, the horizon is a third of the way down, and the limestone arch is positioned on a focal point to give maximum impact. The line of the sea, the beach, and the distant rocks all help to lead the eye round to this extraordinary headland. The composition is quite simple, yet effective. I used masking fluid for the foam on the sea and on some of the pebbles, as well as splattering colours across the foreground.

Viewfinder

The best way to paint a landscape is to sit directly in front of it, but this can be quite daunting for the beginner. How much of the view should you put in or leave out to achieve a pleasing composition? A simple viewfinder will help you to frame a scene, just as you do with a camera. To include more or less, simply move the viewfinder closer, or further away from you. Turn it round to decide whether to paint in portrait or landscape format.

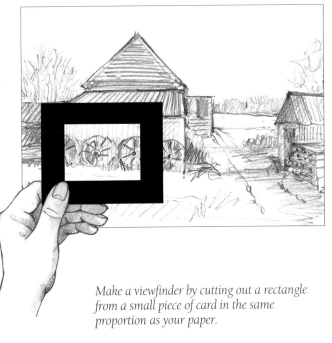

Make a viewfinder by cutting out a rectangle from a small piece of card in the same proportion as your paper.

For *Wheels and Barn*, right, I took time to decide whether the format should be landscape or portrait, and how much of the scene to paint. I made several small sketches before opting for a tighter view, and followed the rule of thirds for more dramatic impact.

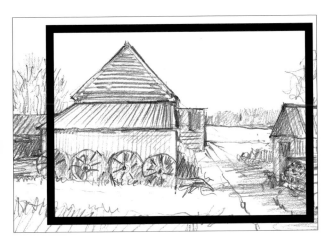

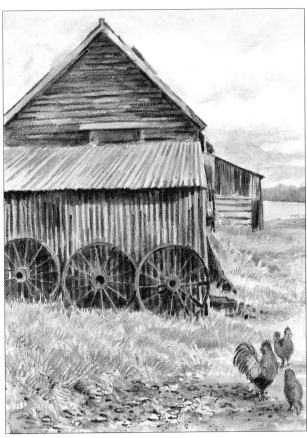

Texture

Sometimes a small detail can make just as interesting a painting as a landscape. While I was looking at old barns (see pages 40-45), I noticed many interesting textures and corners that I wanted to paint, so I took lots of close-up photographs to work on later. Back in the studio, I had great fun. My water soluble pencils gave me the freedom and versatility to meet the challenge of mimicking some of the fascinating textures and colours. All the examples shown are painted on stretched HP paper.

Bale of fencing wire

I drew the shapes of the wire with a range of blues and greys, then filled in with pinks, yellows, and purples, leaving the white paper to show through in the foreground as a contrast with the dark tones inside.

Corrugated iron

I love the shape of the contorted shadow, and the green lichen which looks like a tiny army standing along the top of the rotting wood. I used a full range of colours, and successive layers of washes to enhance this colourful corner. Even though the shadow on the corrugated area is dark, I have retained lots of warm colours here to make it glow.

Rust

I coloured in the background with a pale turquoise pencil, then added water. While the paper was quite wet, I made splodgy marks with burnt sienna, golden ochre, raw sienna and chocolate brown. I dropped in pencil scrapings as well, and let drops of water fall onto the coloured areas, forming 'cauliflower' effects (run-backs).

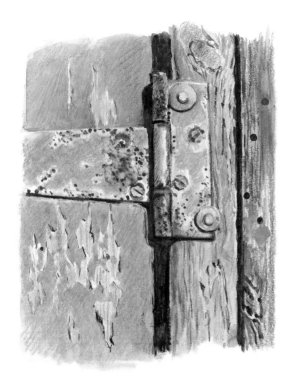

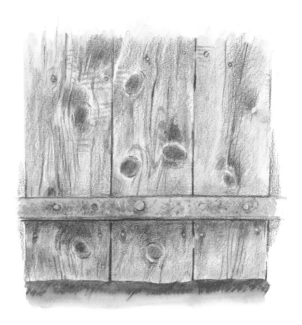

Old gate

I used several browns to create the background colour of the wood, which I then wetted. I allowed the wash to dry, then began to draw in the grain. The process was repeated, leaving dry pencil on top for maximum texture.

Hinge and door

Bright sunlight enhanced the shadows on the peeling paintwork. I created washes of raw sienna and pale green, letting them dry before reworking them with a dry pencil, gradually building up the textures of the rust, the paint, and the grain of the wood. I used wetted indigo and black pencils to draw in the very dark shadows and tiny holes, and left lighter highlights around the areas of rust.

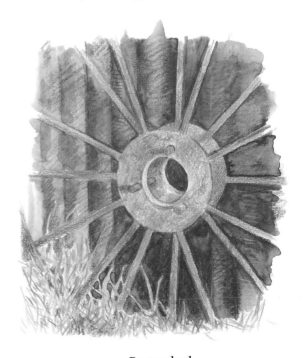

Rusty wheel

Greens, ochres and pale browns — mostly left dry — were used for the hub and spokes of the wheel, and dark blues and indigo washed in for the dark shadows on the corrugated iron.

23

Windmill on Water

Nothing can replace on-the-spot sketching or painting, so make time to sketch as well as taking photographs. This helps to create a better composition by combining the atmosphere captured in a sketch with the accuracy of photographs. In this case, I wanted to make sure the horizon line did not bisect the painting - remember the rule of thirds (see page 20).

The sails of this windmill proved quite difficult to capture, so I used an enlarged photocopy of the scene, drew over it on tracing paper, then traced the image down on the paper. Some of the struts outlined against the sky were too fiddly to paint round, so masking fluid was ideal for this project.

I did not want the blue boat in the foreground because it would have dominated the picture. There was a constant stream of people walking along the towpath, so I added some figures for scale and interest. Although the reflections are lovely, there is quite a large stretch of water in the foreground. Adding a family of swimming geese breaks this up as well as leading the eye into the picture.

You will need:
Stretched HP paper
Tracing paper
Fine felt-tip pen
Tracing-down paper
Masking fluid
Silicone-tipped shaper
HB pencil
Water soluble pencils
Brushes: Nos. 10 and 8
Water pot
Putty eraser
Dip-pen or ruling pen
Absorbent paper

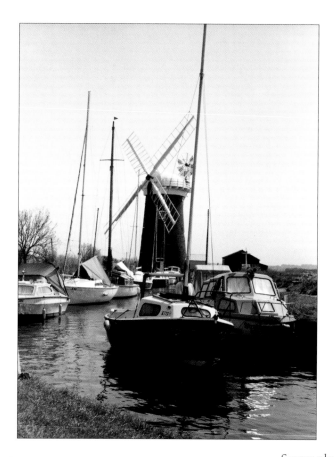
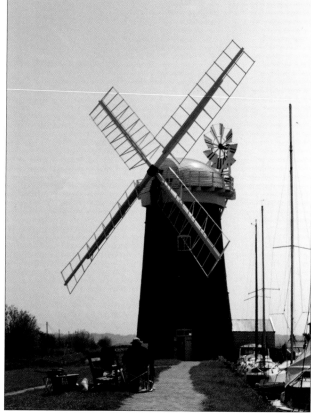

Source photographs

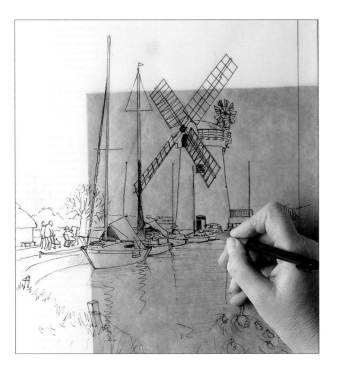

1. Plan your composition on tracing paper using a fine felt-tip pen. Transfer the image to watercolour paper using tracing-down paper and a harder pencil or an old ballpoint pen. Do not press so hard that you dent the paper!

> **Note** *Do not scribble over the masked areas — the pressure of the pencil point may lift off the masking fluid.*

2. With a dip-pen or ruling pen, apply masking fluid in the areas where the sunlight catches the windmill sails and the mast of the boat. With a silicone-tipped shaper, mask out the geese.

3. Sharpen some of the outlines and make guide marks to show where the reflections will fall — these can be made with the colours you plan to use in the final artwork. Scribble in the sky with a mid-blue pencil, fading towards the horizon.

Note *If you have made some areas of the sky too dark, you can rub out some of the colour using a putty eraser before you apply water.*

4. Using a No.10 brush, apply plain water to the areas which you have scribbled.

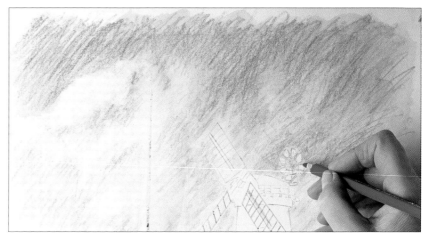

5. While the area is still wet, use absorbent paper to blot out the areas of cloud.

6. Add more of the mid-blue to deepen the effect and achieve distance in the sky. The sky should appear bluer at the top of a picture, so use a slightly deeper blue. For the white areas, simply let the paper show through. Allow the painting to dry after each stage or use a hairdryer.

7. Add more water to the sky, blotting the clouds as you go. Allow your work to dry.

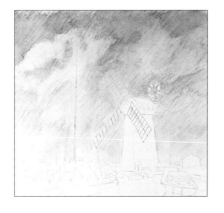

8. Using the same mid-blue, begin to add a little colour to the water. The reflected water is lighter towards the horizon, a mirror image of the sky.

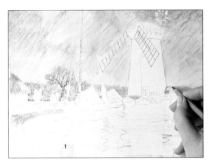

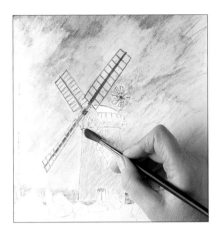

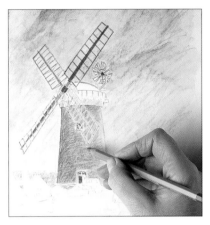

9. Add the line of trees in the background, using a darkish, blue-green pencil to suggest distance. Put in the grass behind the people on the towpath using bright green. Sketch in the willow using brown pencil, and the roofs with a slightly darker brown. With a blue-grey pencil, add the barn and small shed on the right of the mill building.

10. Draw in the sails of the windmill, taking care not to press too hard on the masked areas. With yellow ochre to give a warm undertone, hatch in the body of the mill. Add red highlights to the tail vane. With a No. 8 brush apply water to the mill building. Allow to dry.

11. Put some pale blue pencil under the gantry to represent shadow – the light source is from the top right. Use a little grey pencil on the door and window areas. Build up the tones in the brickwork using reds and browns, terracotta and a little scarlet and cadmium red, tending to a purplish tone on the shady side of the building.

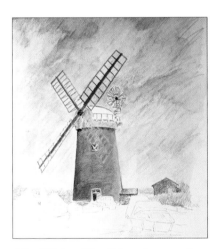

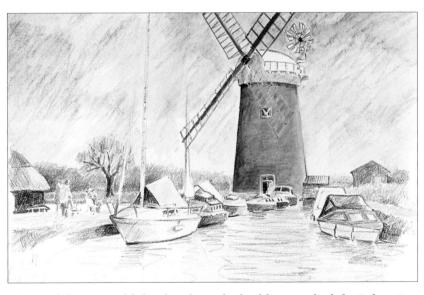

12. With a No. 8 brush, wet the body of the windmill and blend in the colours. Do not worry if it looks a little flat at this stage, because you can go back in and build up the tones by degrees. Add some blue pencil to blend in the colours on the doorway.

13. With brown, add the thatch on the building on the left. Colour in the figures, and add the reflection of the mill with the same colours as were used for the building. Outline the shapes of the boats using pencils in blue-grey, brown, dark red, blue and black. Begin to define the edges of the banks in varied brown shades.

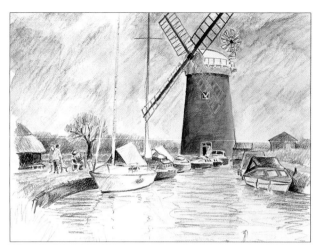

14. Sharpen up the details on the boats and the people on the towpath. Using a variety of browns, continue painting the edge of the canal bank and add the reflections to the water.

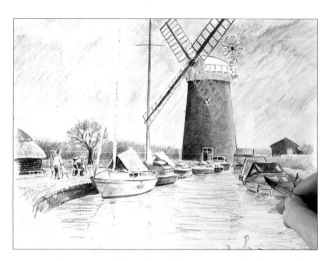

15. With a No. 8 brush, add water to the boats, the people and the mill building. To paint in small details – such as the people – you can simply pick up a little colour from another area on your brush (see the small palette, page 13). Put some brown pencil on the top part of the mast, then add water and blend it in.

16. Scribble in the foreground grass using yellow, then wash it in using plain water and a No.8 brush. With a wet-into-wet technique, add green tones ranging from medium to dark. Allow to dry, then use brown pencil to add more details including the post on the bank.

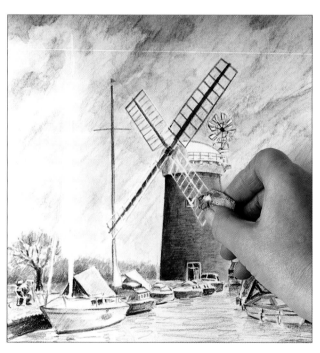

17. With a putty eraser, remove the masking fluid from the sails and the mast of the boat on the left.

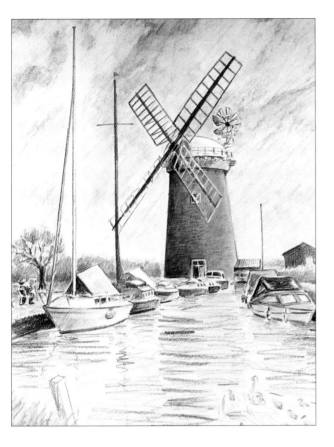

Note *Use a sandpaper block periodically to sharpen the tip of the pencil as you work.*

18. Add detail to the mast on the left with a sharp, blue-grey pencil, using a rule to obtain a clean line. The line should be darker where it passes over a light area of sky, or the finished effect will be wrong. With black and ultramarine blue pencils, sharpen up the detail on the sails.

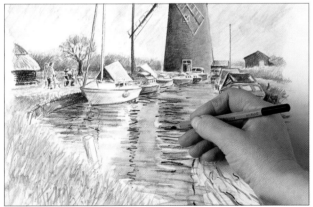

19. With a No. 8 brush, add water to the reflections, drawing into them with the wet brush but allowing some white paper to show through. Using a wet-in-wet technique, add colour to some areas to vary the effect. Use the brush to take a small amount of colour from a blue pencil and apply directly to the wash to soften it. Add the wake behind the group of masked geese by painting on ultramarine, yellow and a little yellowy gold, then adding some black pencil.

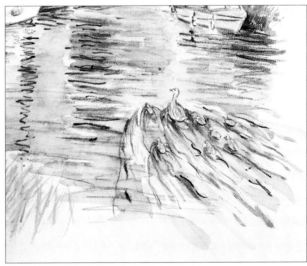

20. Using a blue wash, paint round the outlines of the group of geese to make them stand out on the paper. Allow your work to dry thoroughly, then remove the masking fluid.

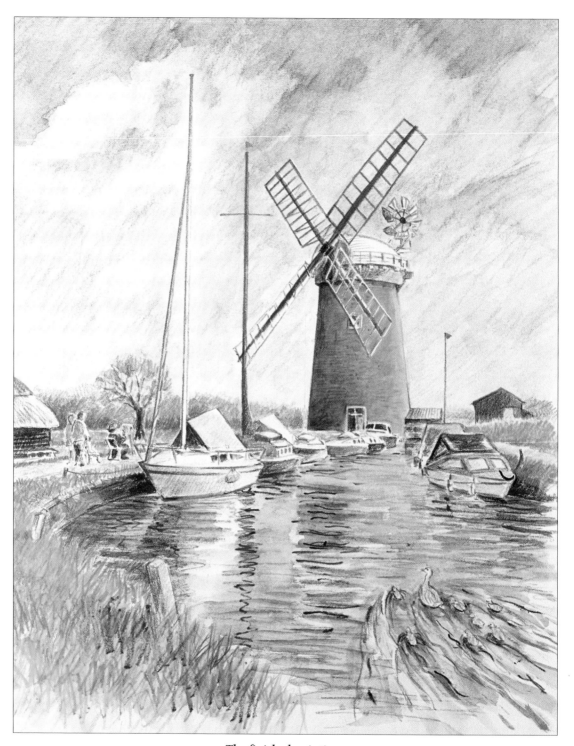

The finished painting

The painting has been worked over to refine details, darkening the river bank to make the boats stand out better and softening the wake behind the geese so they lead the eye into the composition rather than drawing it down. Stubby pencils are useful for this as they give a softer effect and make a broader mark.

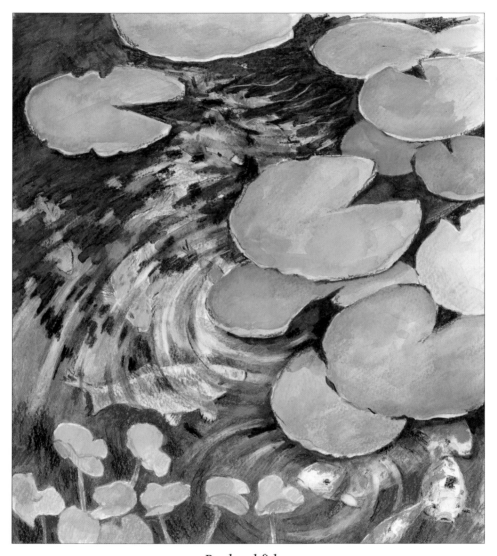

Pond and fishes

I used a pale blue tinted Bockingford paper, which is left unpainted in some areas for the reflections of the sky. For the very dark reflections, I drew into wetted areas with indigo, Delft blue and black to intensify the colour. The foreground leaves were very bright, so I used lemon, bright green and cadmium yellow; for the waterlily leaves a mixture of cooler greens and blues was used in layers. I added some white with stubby pencils to brighten the highlights on the water.

Garden

The main feature of this composition is the statue from the photograph below left. I would like it to be approximately a third of the way in from the right edge of my picture, balanced by a splash of colour provided by the urn of marigolds in the photograph (below right) occupying the focal point of the foreground. These elements will therefore be arranged in line with the rule of thirds (see page 20).

The photographs were taken on a bright, warm summer day and I want the painting to retain this feel. The source of light in the main photograph is strongly from the right, so I will adjust the shadow on the pot of flowers accordingly. Adding a path between the urn and the statue will lead the eye into and round the main feature, and will also offer a change of texture. Too much foliage and grass would make the composition fussy.

The predominant colour is green, so highlights of both warm and cool colours should be added throughout to provide interest; look at the colour wheel on page 12 to find complementary colours. Use blues and purples for the shadows, which should be as interesting visually as the rest of the picture; look for their negative shapes. The strong light and shade will help to define leaf patterns.

I particularly like the various types of foliage. I will use different marks to delineate them, and I will heighten the colour of the large leaves on the rheum (a plant of the rhubarb family) to make them stand out from the rest of the foliage.

The source photograph

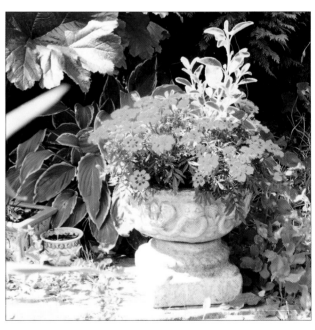

This urn — a detail from a second photograph — will be used to add colour and interest to the composition.

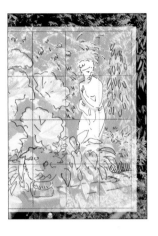

1. Draw a grid on tracing paper to overlay the main photograph. Sketch in the main elements of your composition.

You will need:

Tracing paper
Tracing-down paper
Watercolour paper
Graphite pencils
Water soluble pencils
Brushes Nos. 8 and 5

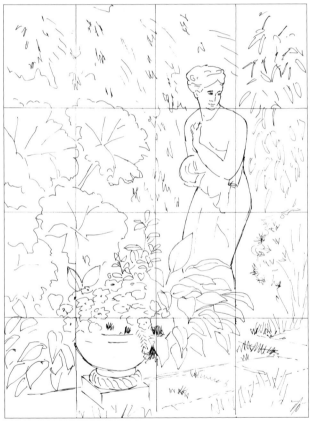

2. The finished painting will be about two-and-a-half times larger, so make up another grid, enlarged in proportion, on tracing paper and sketch in the statue, the foliage, the urn and the path.

Note When transferring outlines, use a shade of pencil which will blend in with the colours of the painting, but will still be visible enough for you to follow the outlines.

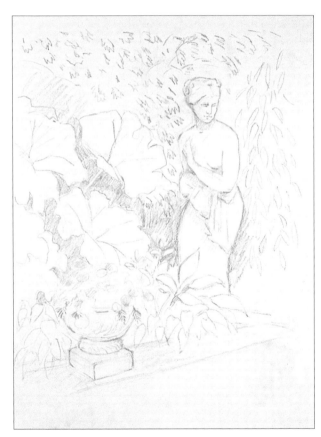

3. Transfer the main outlines of the picture to your paper. Note: I have altered and re-positioned the urn to make a better composition. Sketch in the outlines of the statue and the foliage with medium and dark tones of graphite pencil. Block in colour between the leaves with mid-green, and the flowers in the pot with bright yellow and orange. Scribble in the path with raw sienna. Outline the bamboo leaves and sketch in the conifer with blue-green pencil.

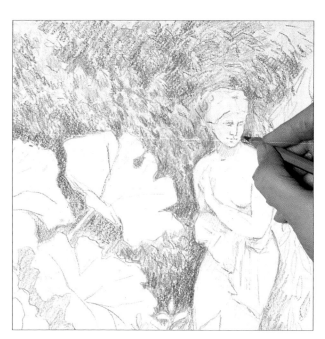

4. With a cool yellow pencil, put in some of the tones of the foliage on the conifer. With blue-green, put in a few well-defined leaves. Add the shadows with dark violet, and accent a few of the leaves with bright emerald green.

> **Note** *Do not attempt to put in all the leaves: a few well-defined leaf shapes will effectively signal the type of foliage.*

5. Add some colour to the bamboo leaves with a warm, gold-toned yellow, a yellowy-green and a bright emerald green. Use violet and indigo to pick out areas of shadow between groups of leaves, adding indigo to tone it down if it looks too vivid.

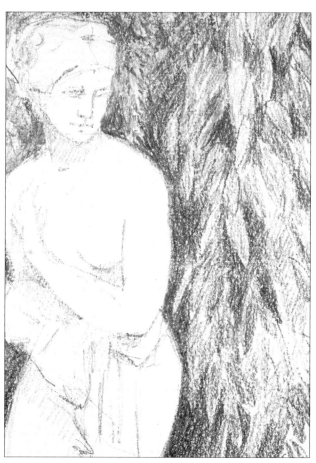

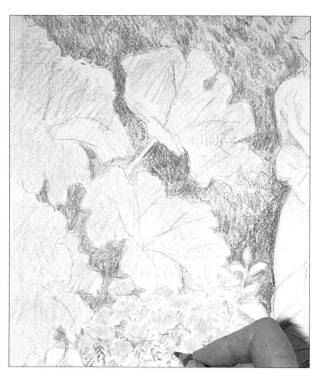

6. Start to build up colour on the rheum leaves with gold, then orange, then bright green. Draw in the ribs using darker green and red. With indigo, put in some darker shadows between the leaves. Put in the foliage between the flowers in the pot using sap green, then add orange, brighter yellow and red accents to the flowers to make them stand out.

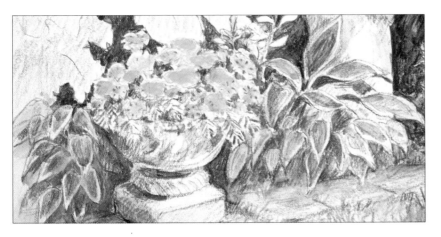

7. Build up the shadows on the urn with ultramarine pencil, remembering that the light is coming from the right. With dark brown, add the earth in the urn. Build up the tones of the hosta leaves using layers of green and yellow. Sharpen up the edges and stalks of the leaves with dark green, then add some shadow with violet and purple.

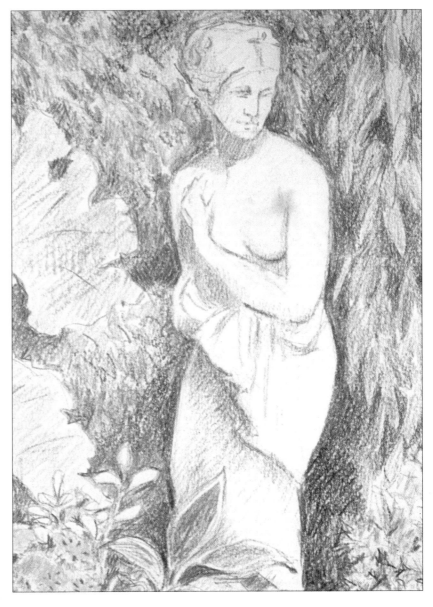

8. Build up the foliage on the right of the statue using a golden brown for the star-shaped parts of the seed heads and indigo for the shadow. Put in the foreground grass with a range of greens, choosing the shades by eye as you build up the tones.

9. Soften the colour of the statue with a touch of gold pencil. Put in some cobalt blue for the shadows – as graphite has already been used for the outline, adding more grey would make the effect too dull.

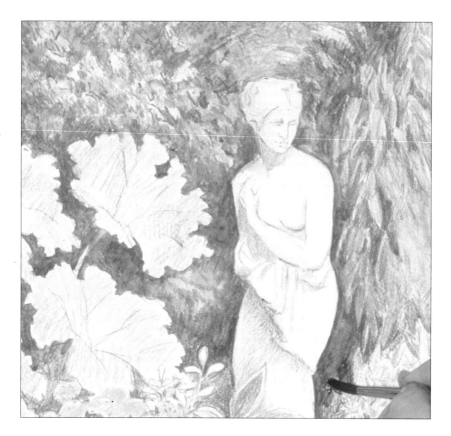

10. With a brush, add water to the foliage in the background. Using a wet-in-wet technique with blue-green, indigo and violet pencils, increase the tonal range by deepening shadows and re-defining the lighter areas of foliage. Do this in small sections, working over each area thoroughly before moving on to the next. Work round the edges of the rheum leaves to give them a more crinkly appearance.

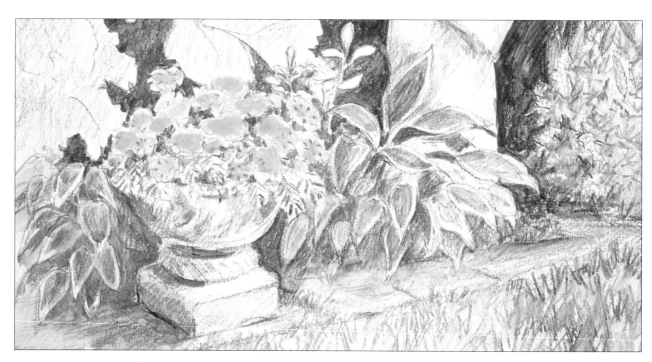

11. Add water to the foreground of the picture, and work over it in sections as for the previous stage, using the same colours.

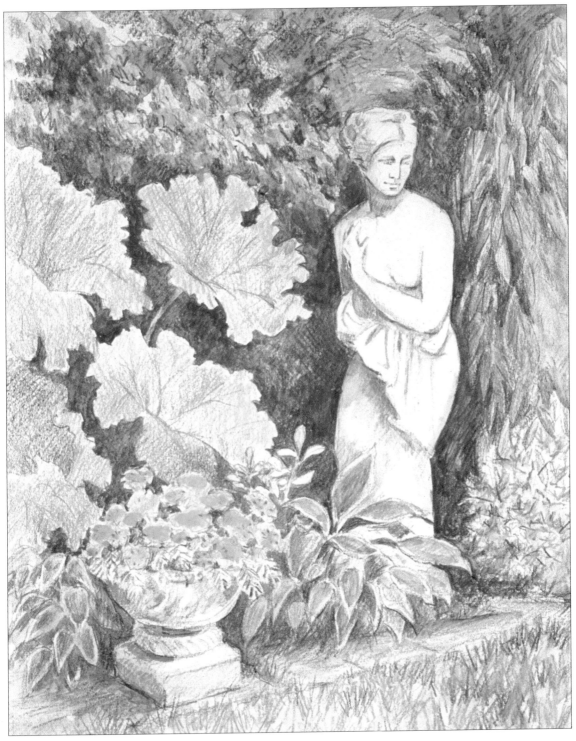

The finished painting

I have increased the tonal value of some of the leaves by intensifying the shadows with blues and purples to make them stand out more. A little more orange has been added wet-in-wet to the flowers.

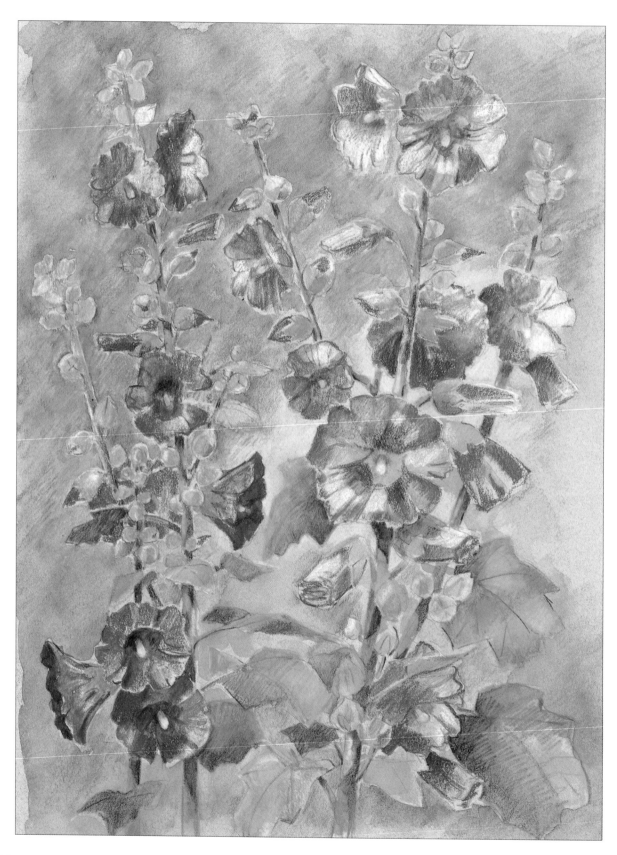

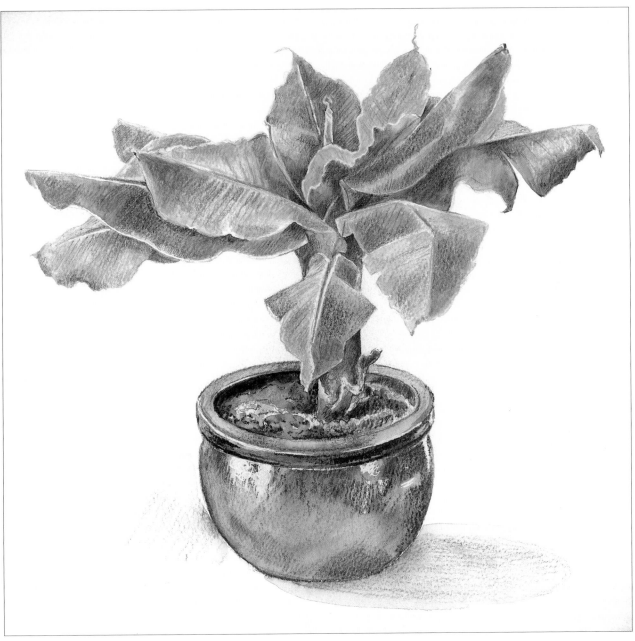

Hollyhocks

I wanted to show the exuberance of these stately summer flowers, so I kept the painting fairly loose and worked on stretched grey pastel paper. I adjusted the background by adding dark blues and cool greens behind the palest buds, and lightening areas behind the darker flowers and leaves to make the subject stand out from the paper.

Banana plant

The plant had overwintered in a corner of my studio. I made an initial sketch to assess the tonal values — the lights and darks give the leaves their shapes. Then I drew the plant with two greens and pale ochre for the leaf tips, adding highlights on the edges with a pen and masking fluid. I masked highlights on the pot and drew it in bright blue, letting the texture of the paper show through. I added water, let it dry, then simulated the glazes by adding dry pencil. I blended the colours in the painting with a damp brush, adding more colour to strengthen some areas and drawing straight into the wet paper for intense effects like the earth in the pot.

Old Barns

I loved the tumbledown appearance and the patchwork of corrugated iron repairs on these old barns, caught in a glimpse of winter sunshine. I made some quick sketches at the scene and took lots of photographs.

Back in the studio, I have decided to change the clear blue sky to a greyer, stormier one to provide more contrast with the light, pantiled roof of the big barn. I have decided to use a tinted paper for this demonstration to give a mellow, warm background colour. This means that the barn roof will need only minimal colour added as the paper will do most of the work.

The old plough in the dry grass (see photograph, page 44) was well away from the barns, but I plan to bring it in to tie in with the blue combine in the lean-to, and to add foreground interest. The dried grasses on the bank and the stubble should lead nicely into the picture.

You will need:

Tinted pastel paper
Water soluble pencils
Broad (stubby) water soluble pencils
Brushes

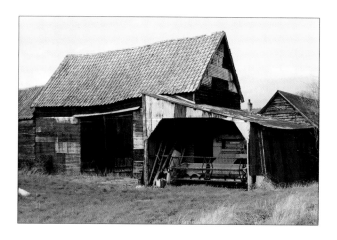

Source photographs

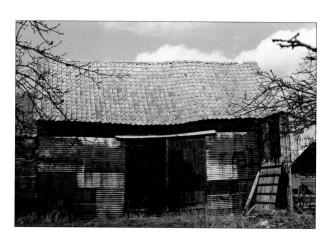

It is better to take too many photographs rather than too few. I have photographed the barn from different angles, and have also taken some close-up shots.

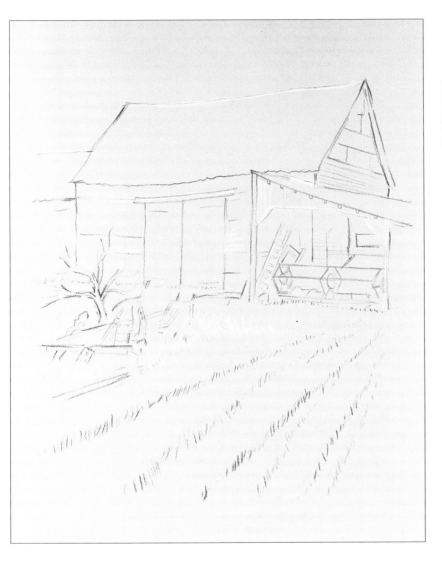

Note *I put in white pencil where the lightest areas are — it reminds me not to add too much colour but let the paper show through.*

1. Draw your composition using mid-brown pencil, adding white pencil where the sun catches the ridge of the roof, the door and the ladder. Add the red machinery.

2. Put in some white pencil for the clouds, then add ultramarine and indigo for the sky to give a brooding, stormy effect.

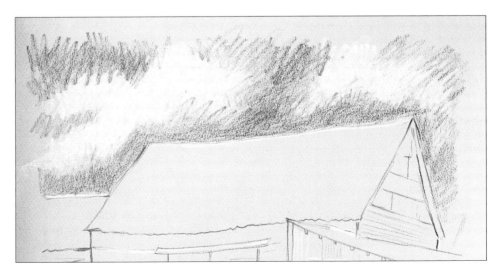

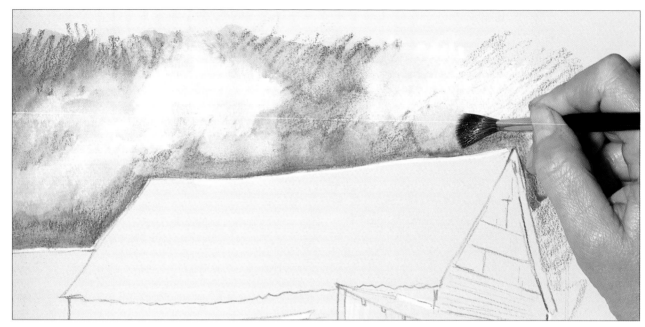

3. Wet the sky and blend in the areas of colour, rinsing the brush as you change from blue to white. The colour change in this case is quite dramatic, but there is no need to worry!

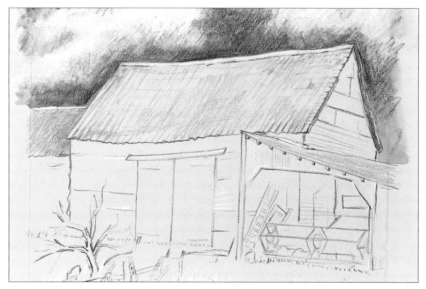

Note *Have a hairdryer handy to help to speed up the drying process. The pencils are not very efficient if you try to work on damp paper, and you may damage the surface.*

4. Begin to put in the roof of the large barn using raw sienna, a muted orange and a pale yellow to add warmth, with the same colours plus a small amount of brown to darken the roof of the smaller barn. Suggest the tiles with a few carefully-placed lines.

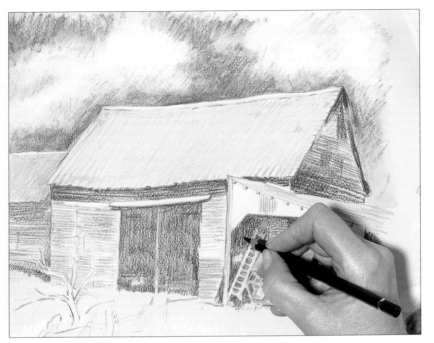

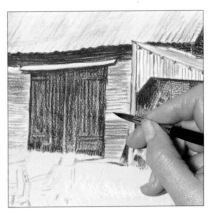

5. Fill in the details on the barn using black and dark brown for the wood planking, orange-reds, browns and blue-greys for the different patches of corrugated metal.

6. With a No. 8 brush, begin to add water to the pencilled areas of barn, lifting the black in places to paint in the corrugations on the metal.

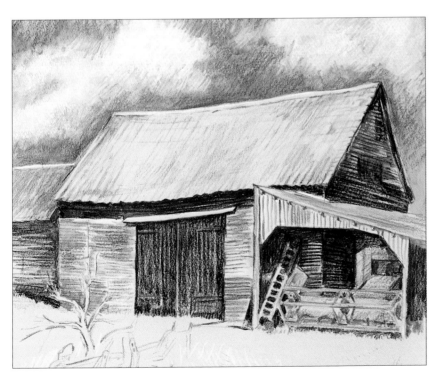

7. Complete the barn, working over a small area at a time and rinsing the brush as you change from black to lighter colours. Lift off black to add accents to the plough in the lean-to.

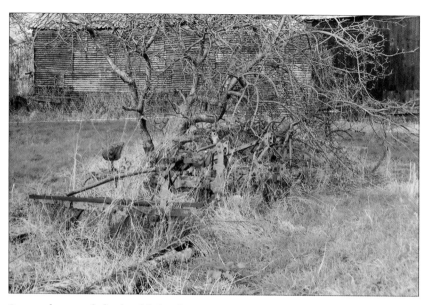

Source photograph for the old plough

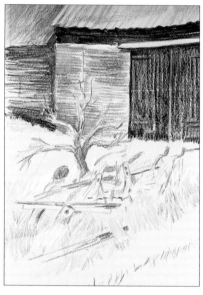

8. Fill in the plough in front of the barns using blue pencil, and the old elder bush using brown.

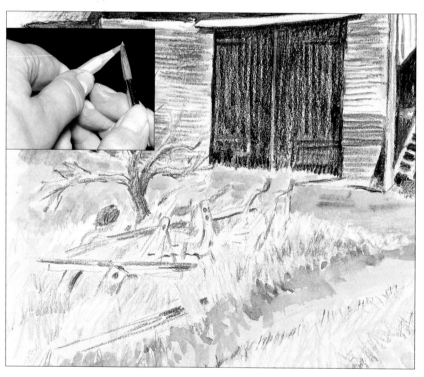

9. For the grass behind the plough, use a wet brush to lift the colour directly from a grass-green water soluble pencil and apply to the paper.

Inset: lifting the colour off with a brush

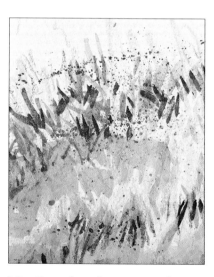

10. Complete the grass in the foreground using green, deep cadmium, yellow and brown for the grass and furrows. Finish by lifting colour from a brown pencil with a brush and spattering it over the grass.

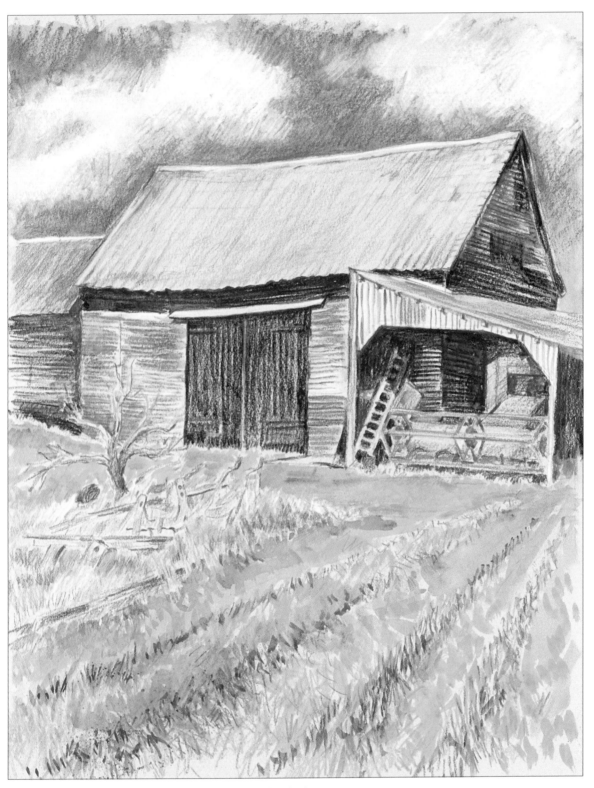

The finished painting

Conclusion

I hope the paintings and drawings in this book will inspire you to try water soluble pencils. They are a versatile and exciting medium which can be used with many other media to produce interesting results.

I have demonstrated my method of working, but you will develop your own style and preferences. Remember there are no hard and fast rules.

Visit art exhibitions and galleries to draw inspiration from the work of artists past and present. Their ideas are stimulating, and it is fascinating to see the range of colours and materials used.

Whatever the level of your ability, work at your drawing and observation skills. Use a sketchbook whenever possible, or take photographs to record anything you find interesting. The more you practise, the more confidence you will gain and your work *will* improve – so happy painting!

Inquisitive Devon cows

I worked from several photographs to produce this painting, using a range of browns, ochres and golds.

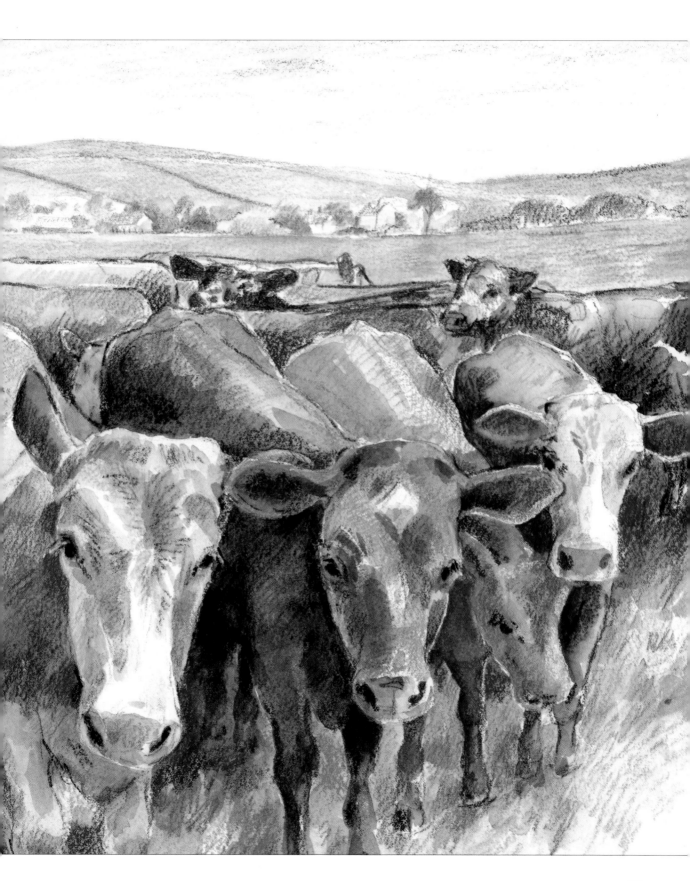

Index